# FRENCH BULLDOGS
## lightweights **littermates**

sharon montrose

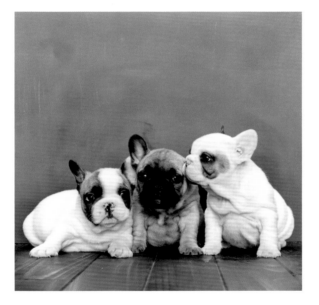

Stewart, Tabori & Chang
New York

Published in 2007 by Stewart, Tabori & Chang
An imprint of Harry N. Abrams, Inc.

Photographs and text copyright © 2007 Sharon Montrose
**www.sharonmontrose.com**

Library of Congress Control Number: 2007928303
ISBN-13: 978-1-58479-635-0
ISBN-10: 1-58479-635-9

Designer: Sharon Montrose
Editor: Kristen Latta
Production Manager: Tina Cameron

The text of this book was composed in Eatwell Skinny & Eatwell Chubby by Chank Diesel.

Printed and bound in China.

10 9 8 7 6 5 4 3 2 1

HNA
harry n. abrams, inc.
a subsidiary of La Martinière Groupe
115 West 18th Street
New York, NY 10011
www.hnabooks.com

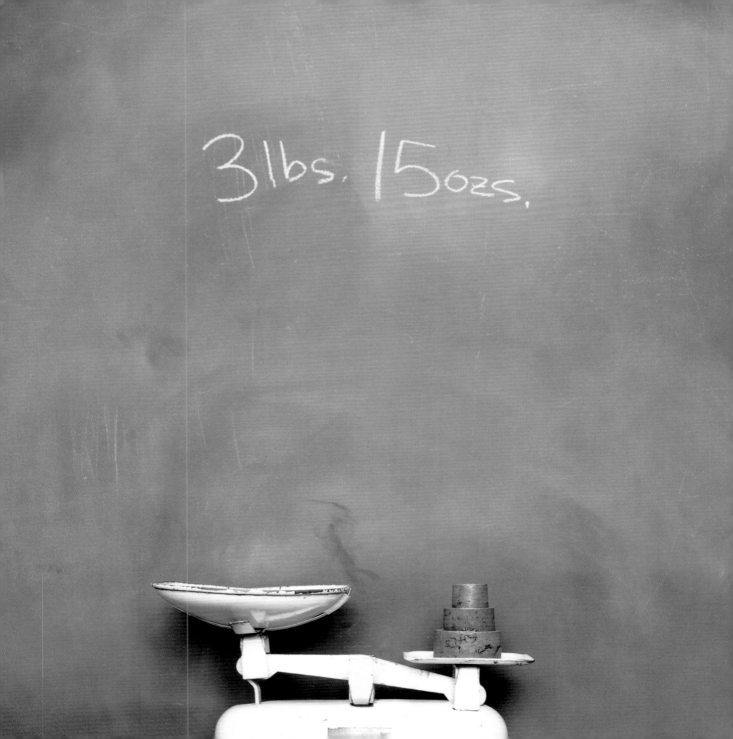

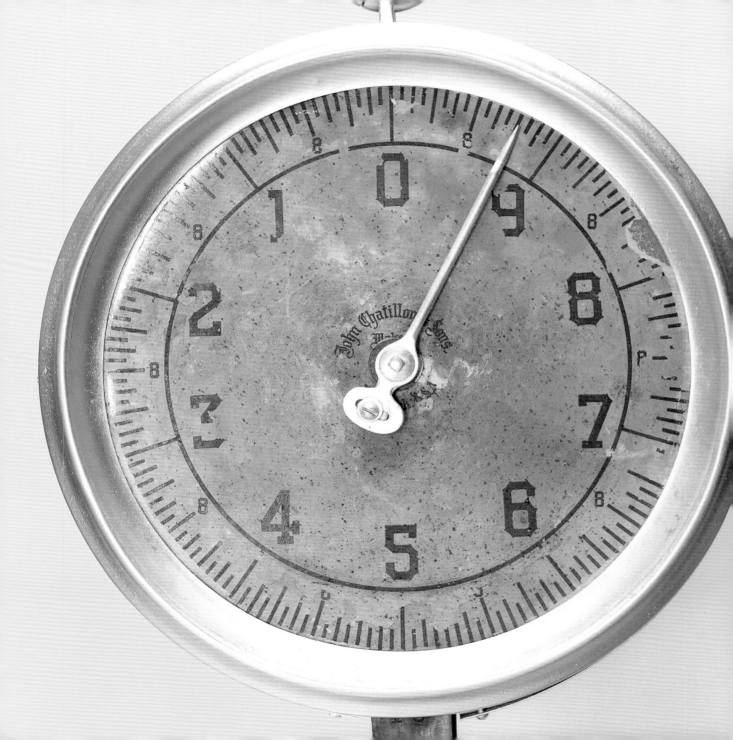

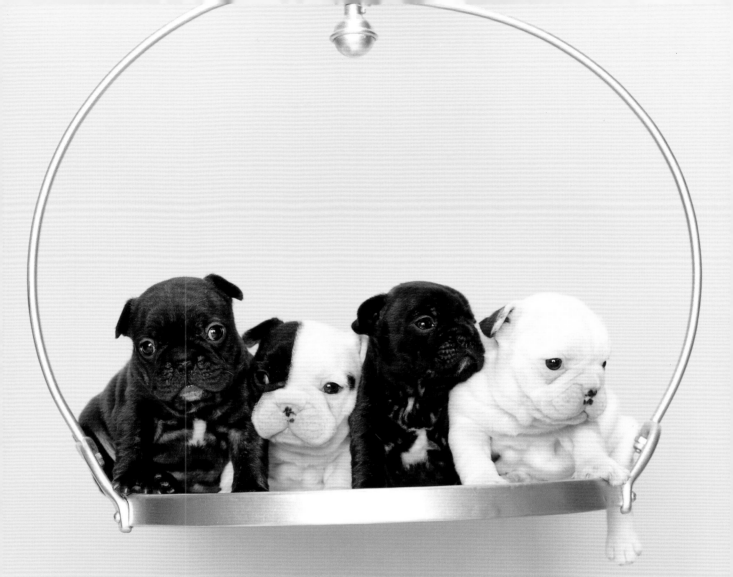

lightweights **littermates** four weeks old

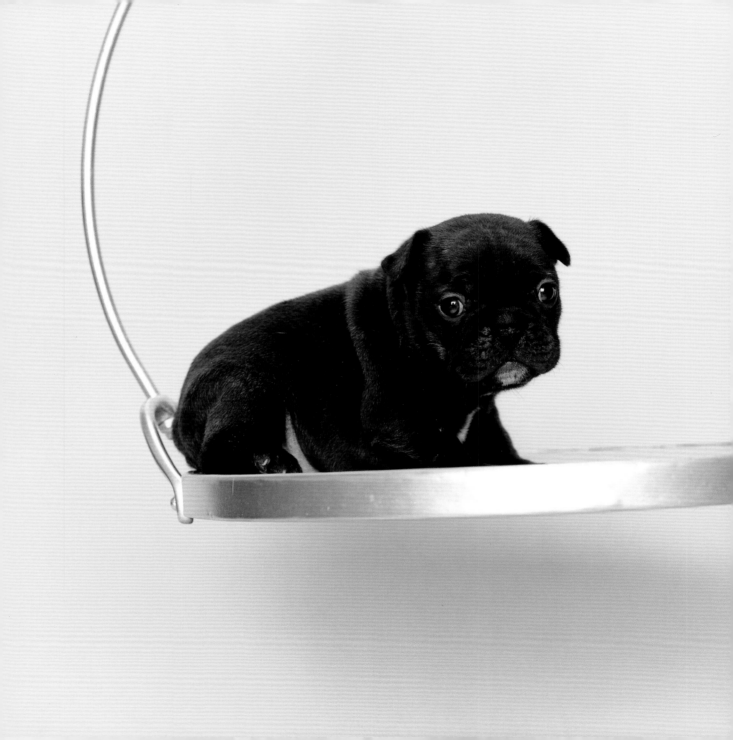

**bartlett** 2 lbs. 7 ozs.

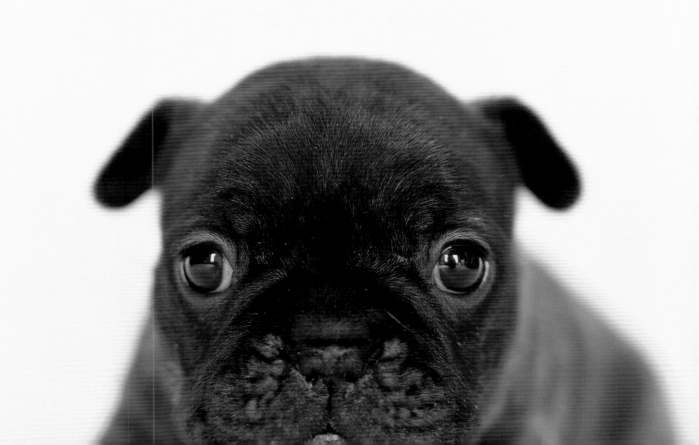

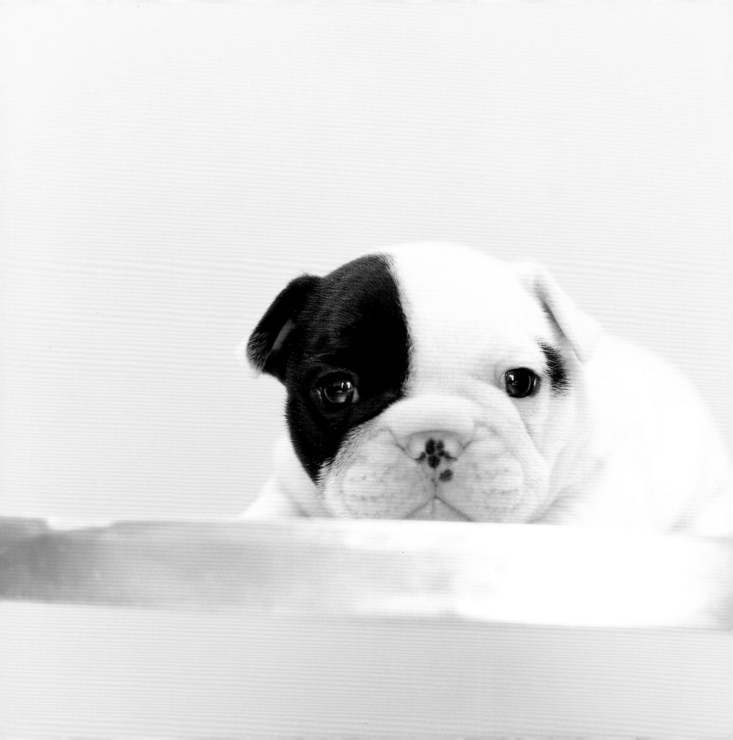

anjou **2** lbs. 12 ozs.

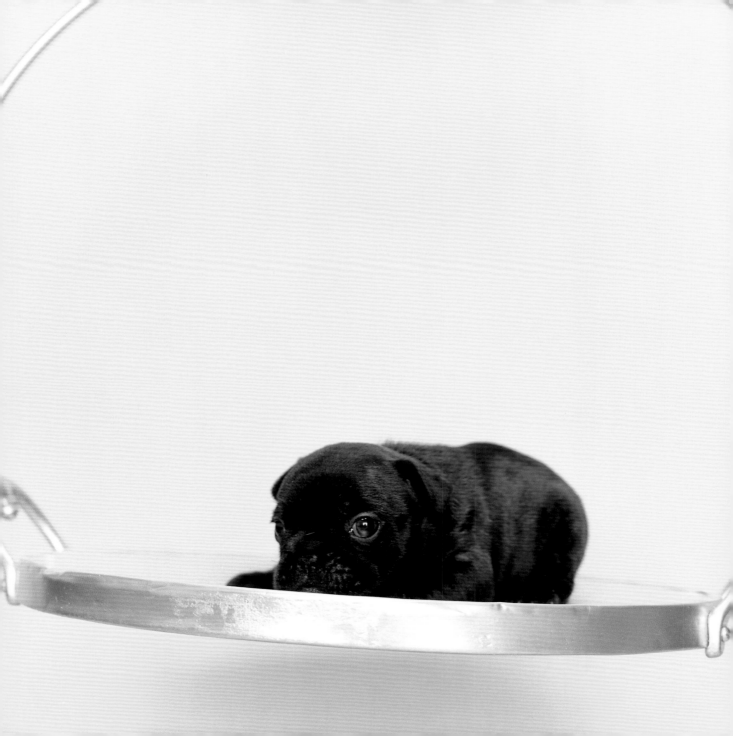

forelle **1**lb.**9**ozs.

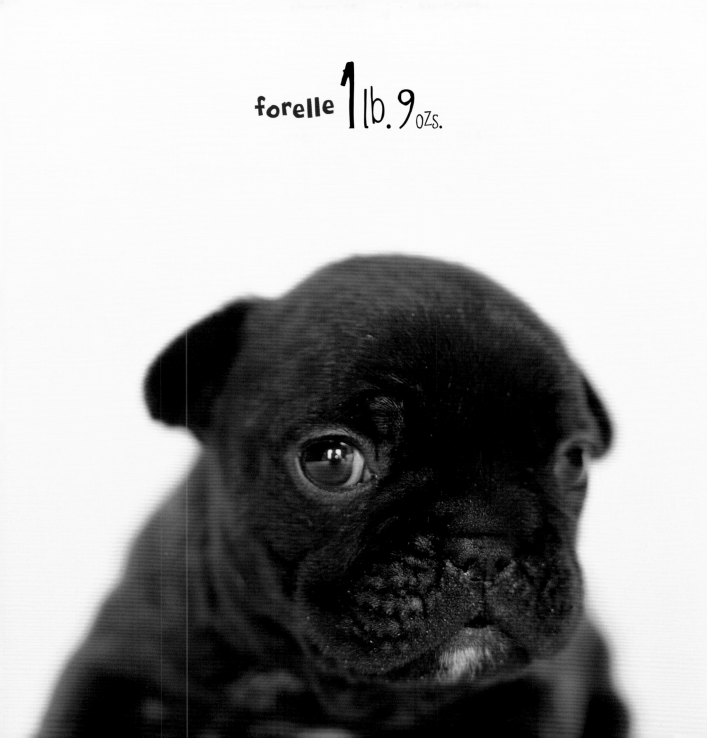

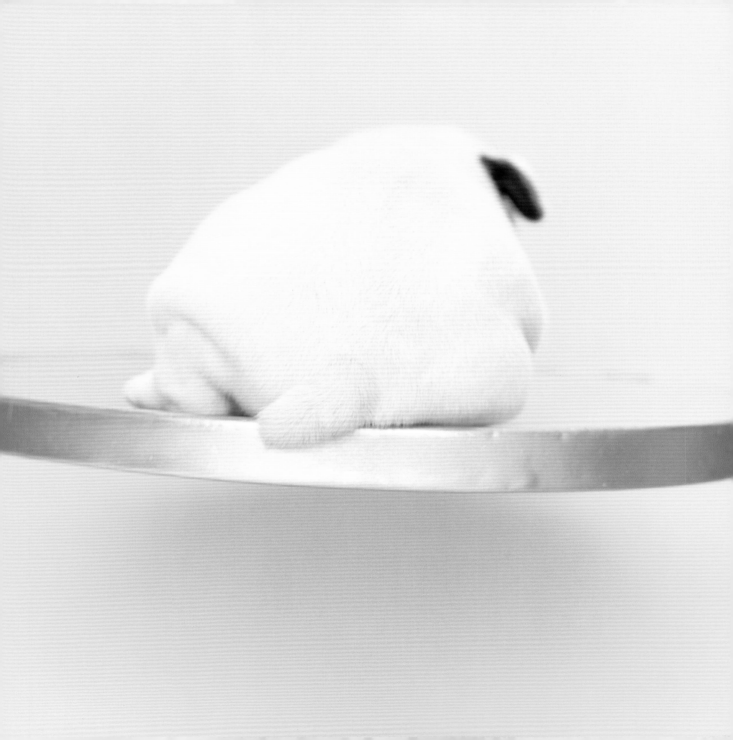

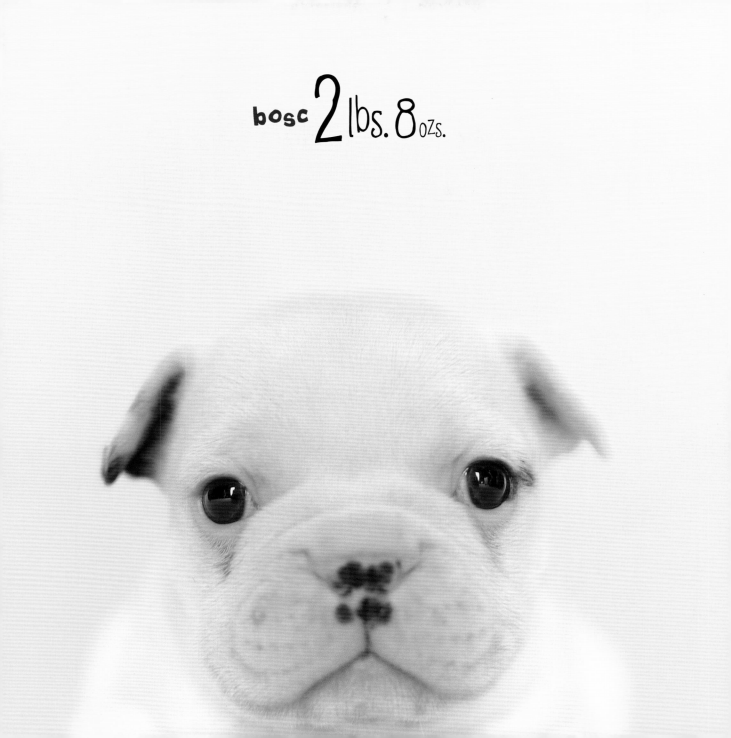

bosc **2** lbs. **8** ozs.

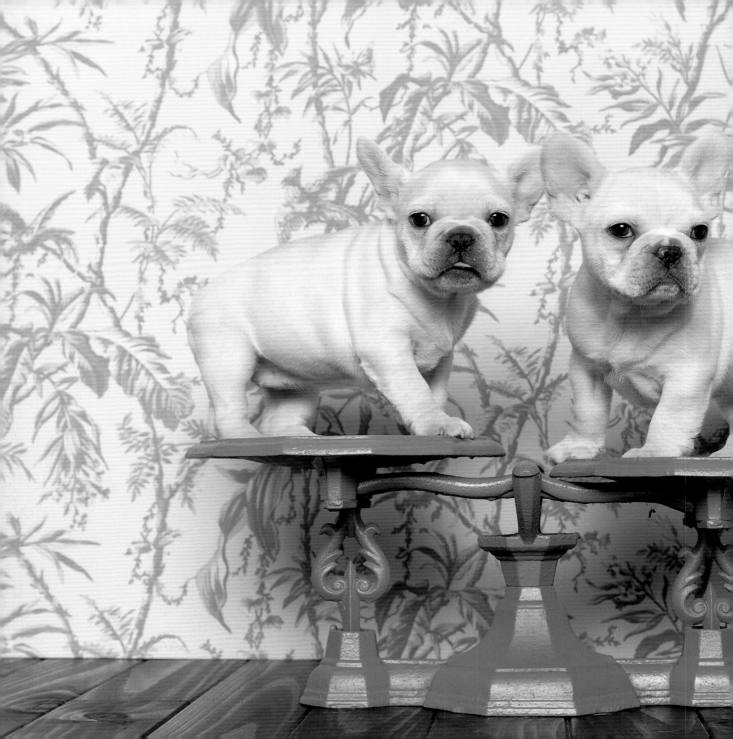

lightweights **littermates**

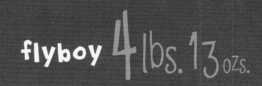

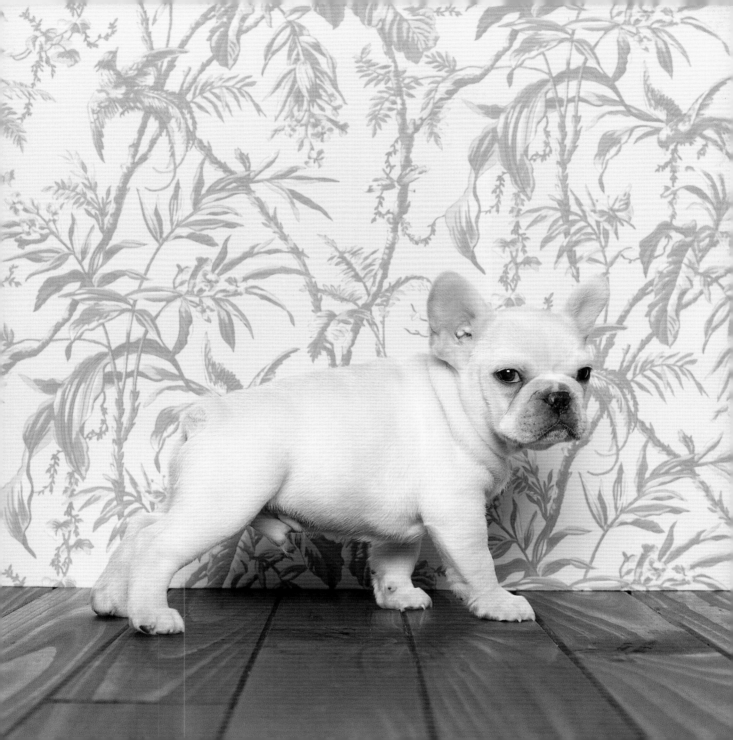

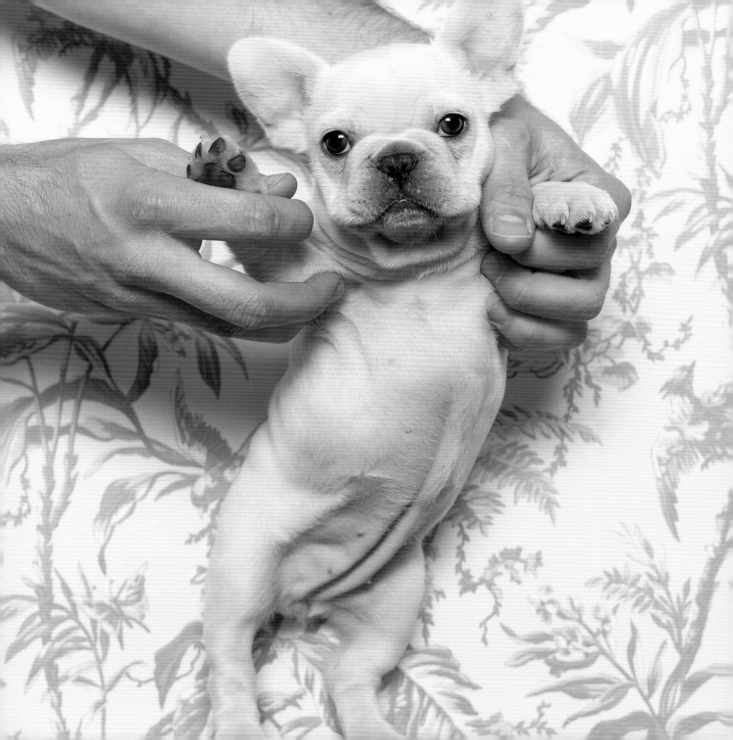

loretta 4 lbs. 5 ozs.

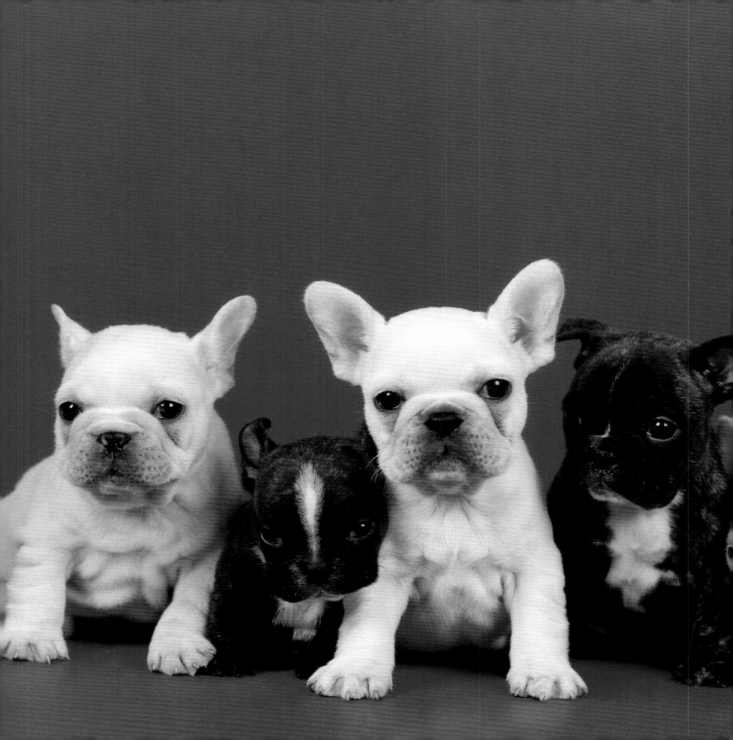

lightweights **littermates** six weeks old

henderson 3 lbs. 2 ozs.

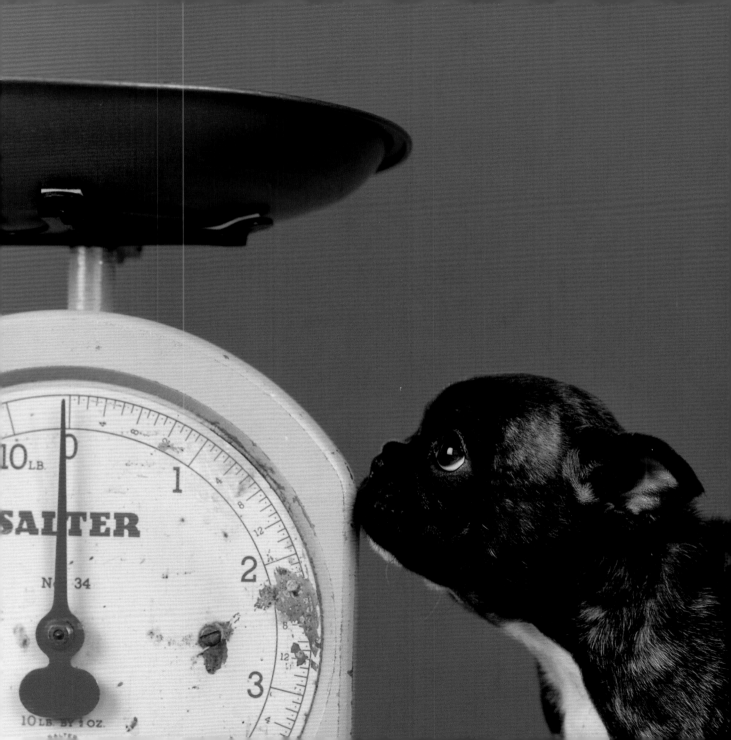

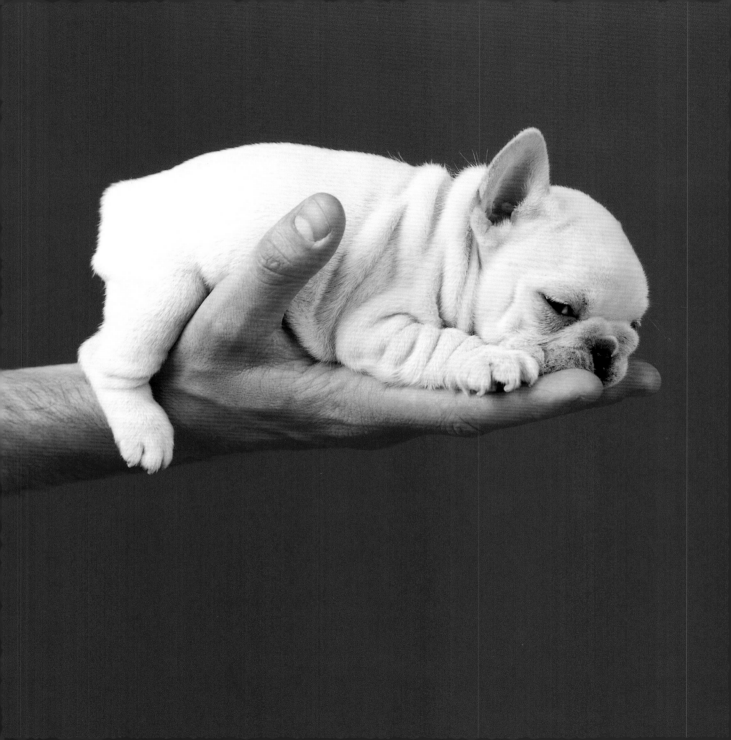

maybelle **2** lbs. **1** oz.

june 3 lbs. 5 ozs.

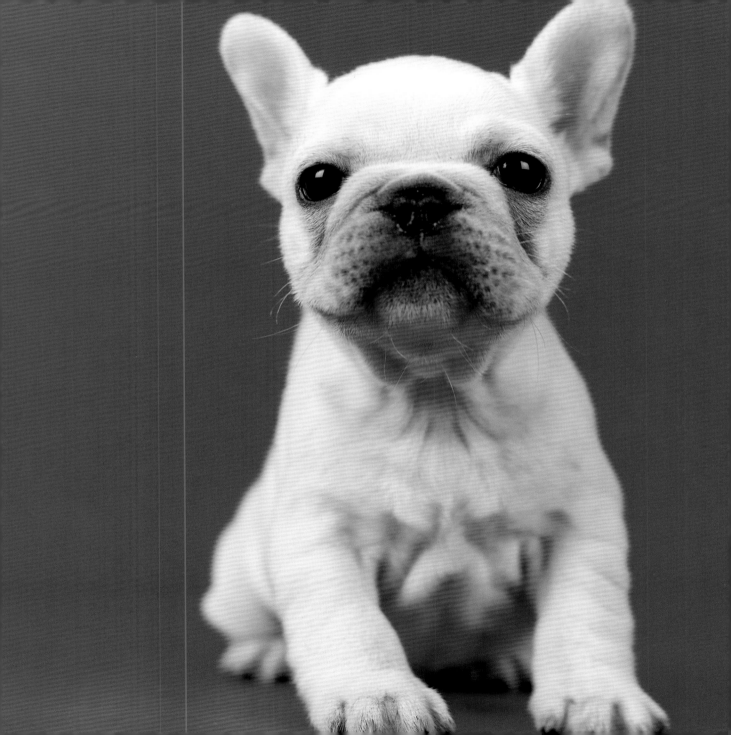

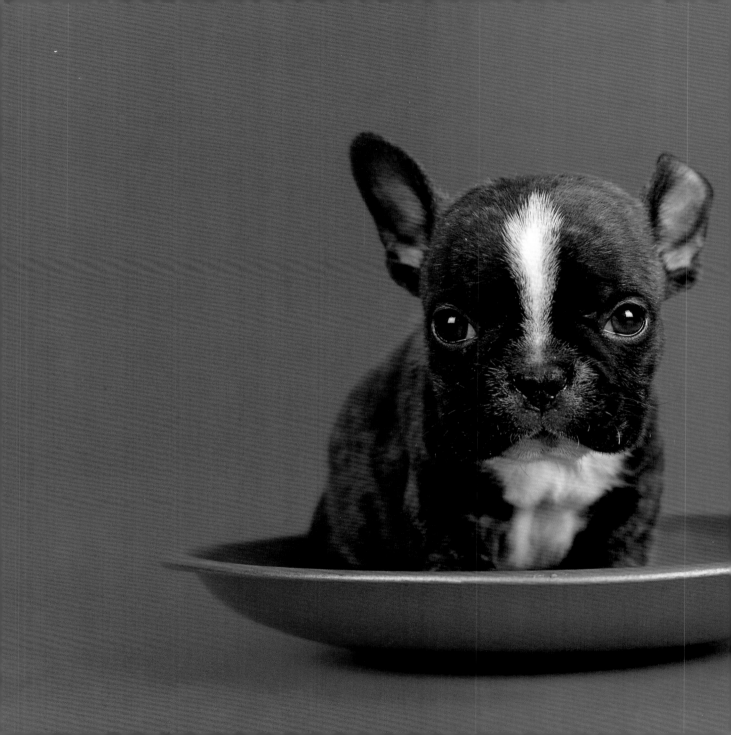

johnny **1** lb. **7** ozs.

rozanna 3 lbs. 4 ozs.

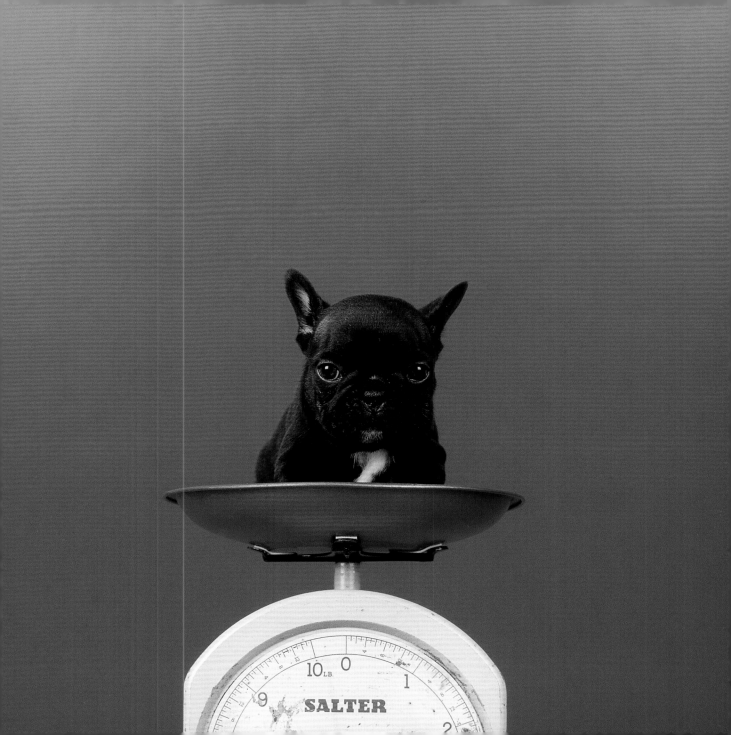

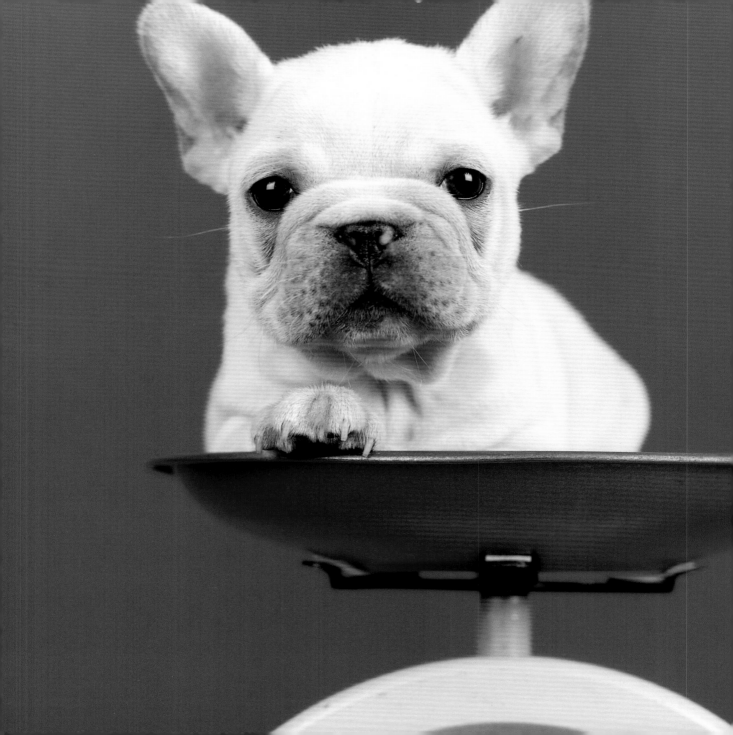

carlene **3** lbs. 6 ozs.

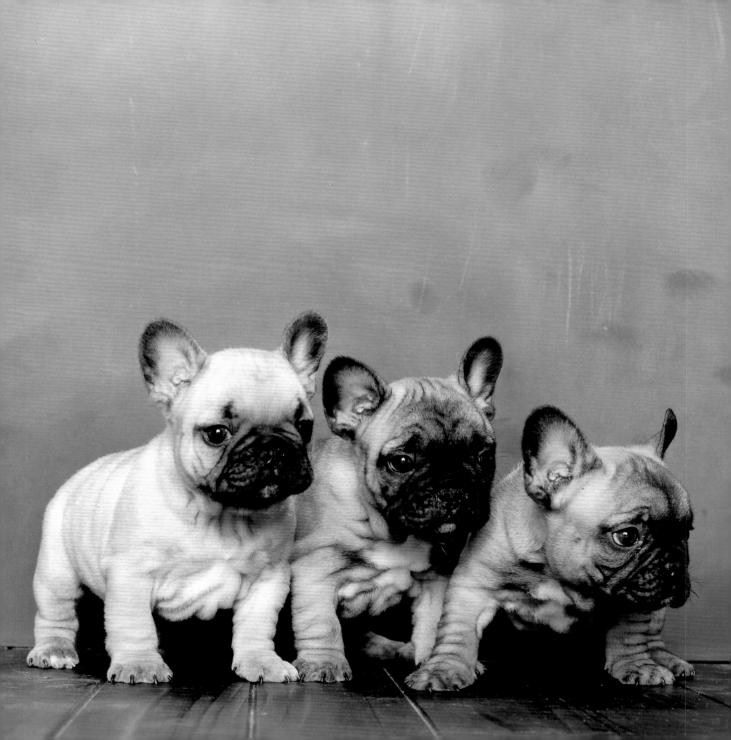

lightweights **littermates** five weeks old

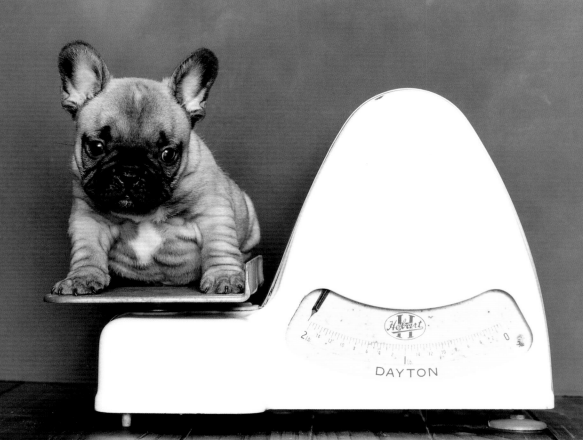

harpo 4 lbs, 8 ozs.

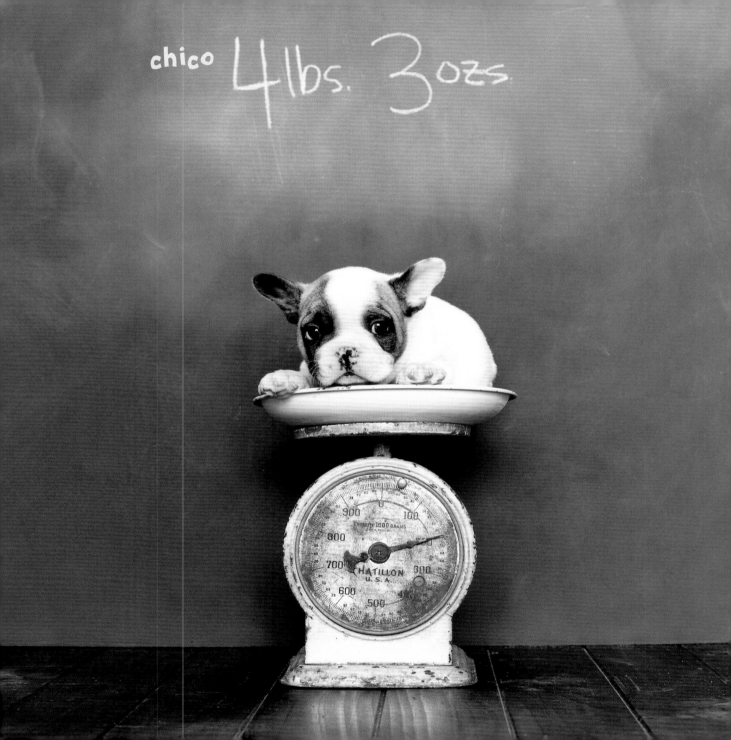

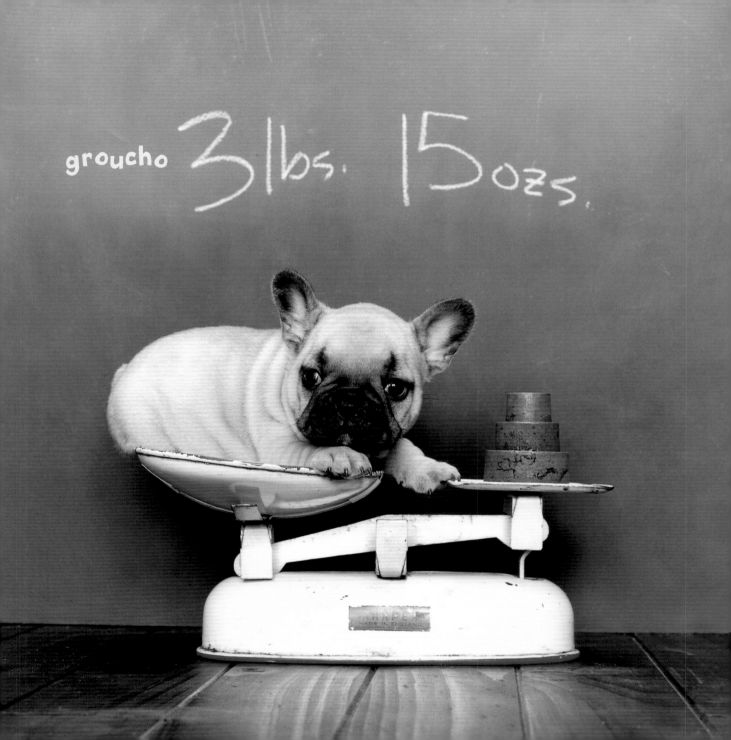

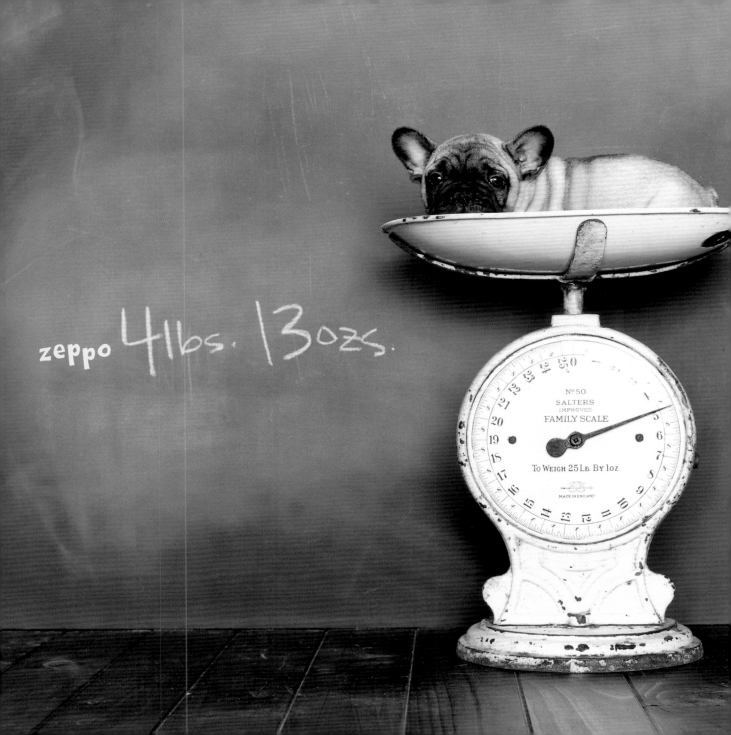

zeppo 4lbs. 13ozs.

vera 3lbs. 6ozs.

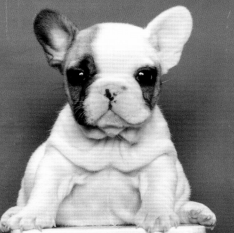

lightweights **littermates** nine weeks old

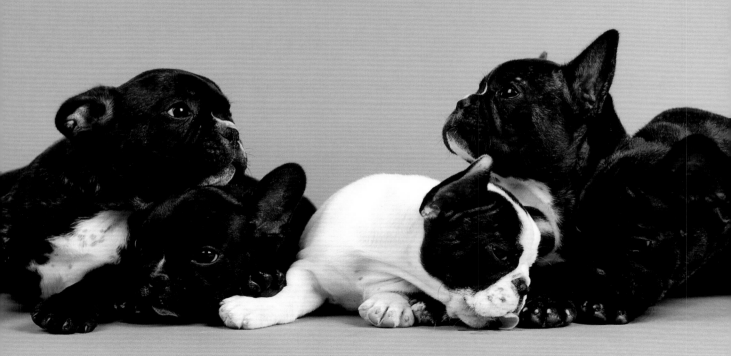

abershane **5** lbs. 0 ozs.

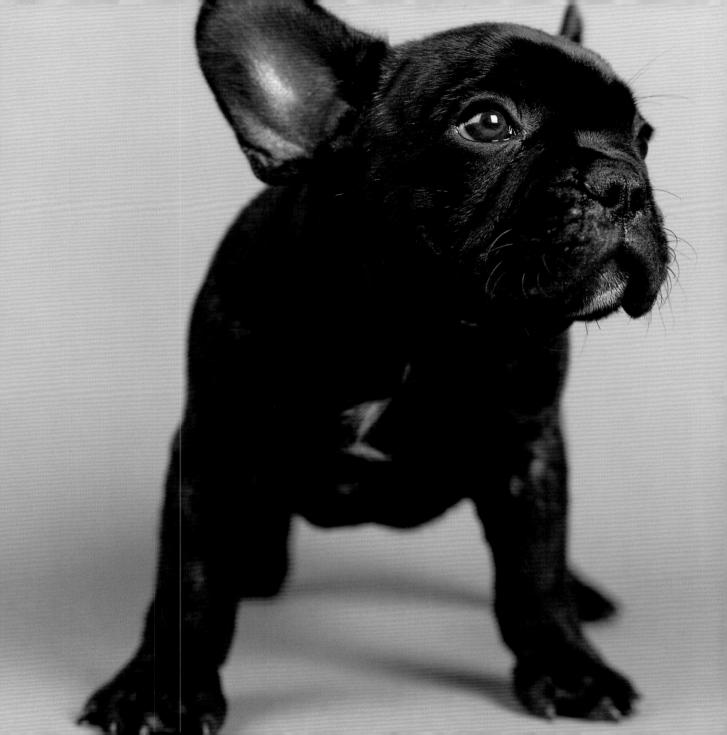

mary frith **6** lbs. **3** ozs.

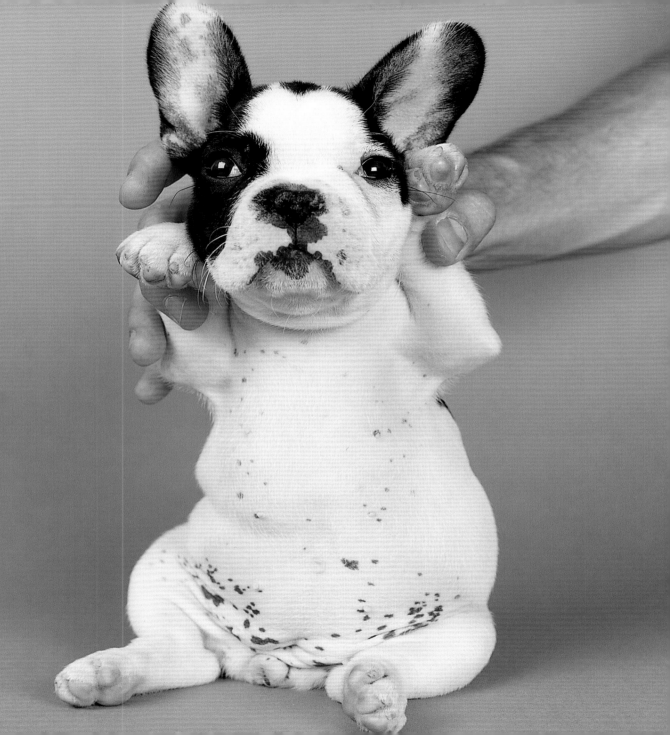

babington 5 lbs. 9 ozs

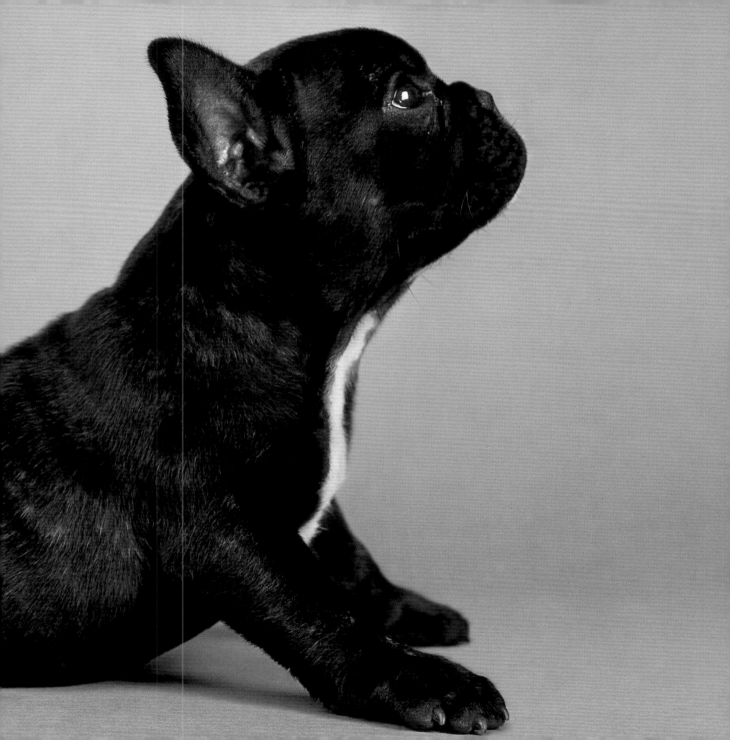

rory **5** lbs. **8** ozs.

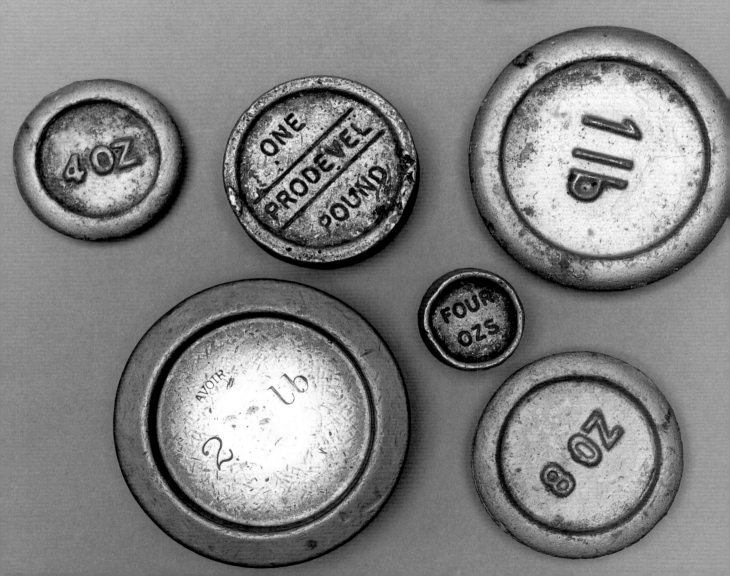

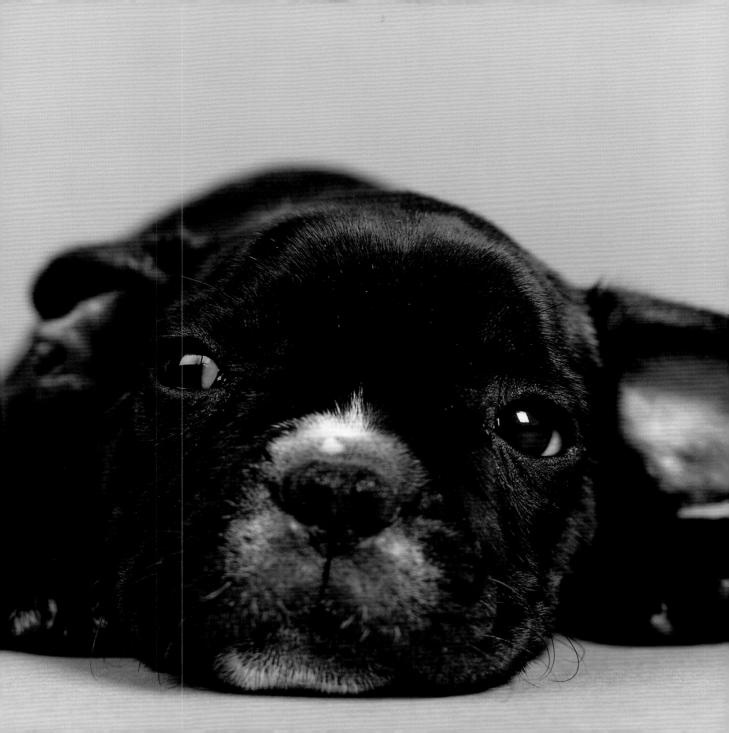

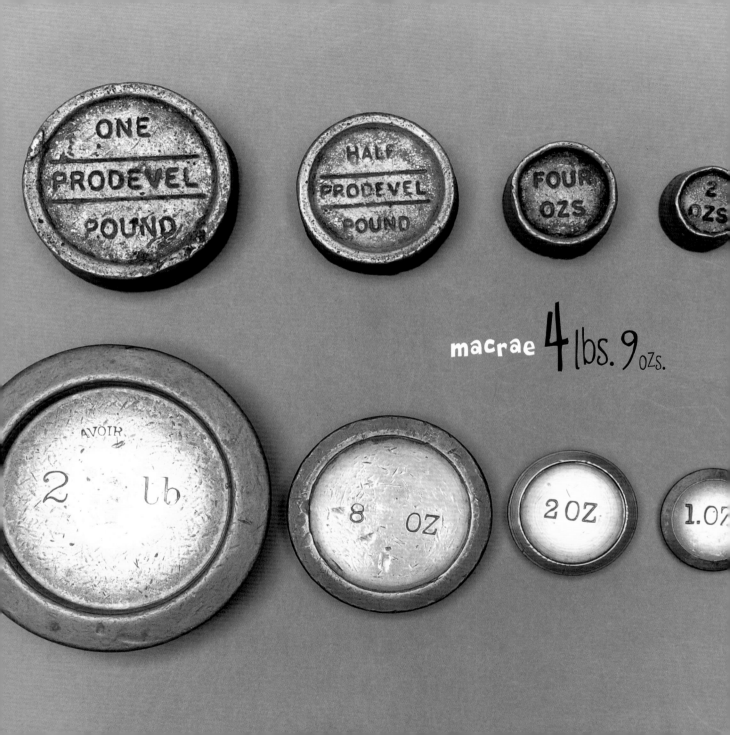

macrae 4 lbs. 9 ozs.

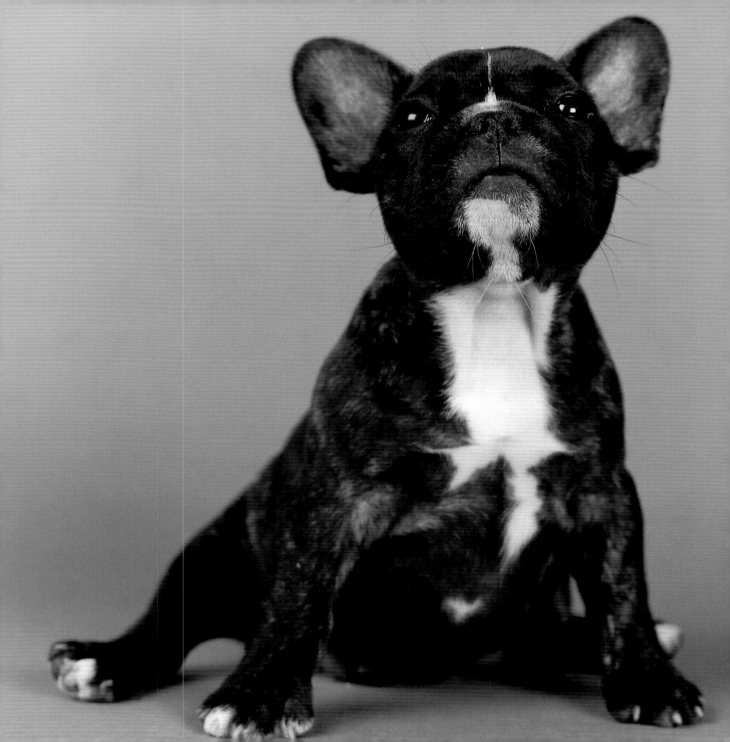

lightweights **littermates** eight weeks old

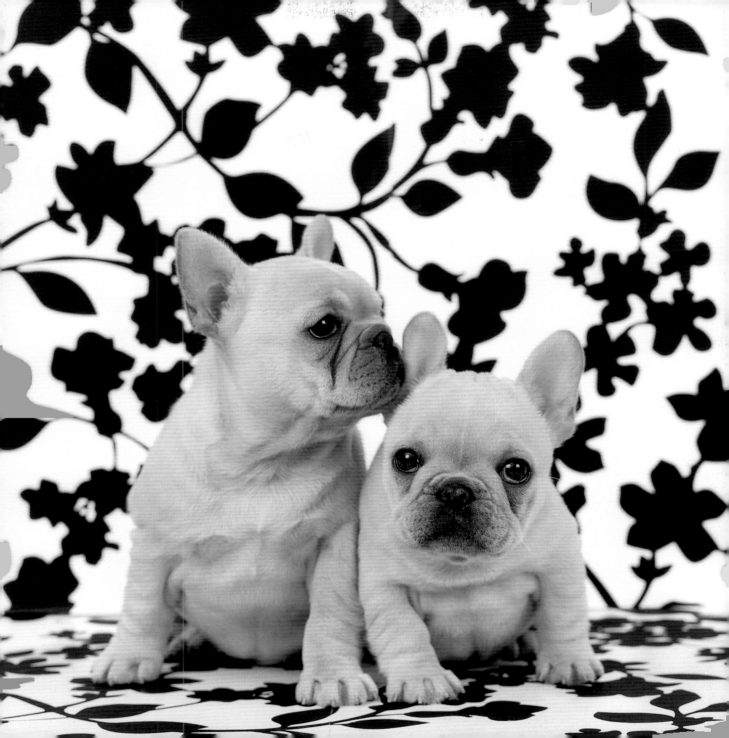

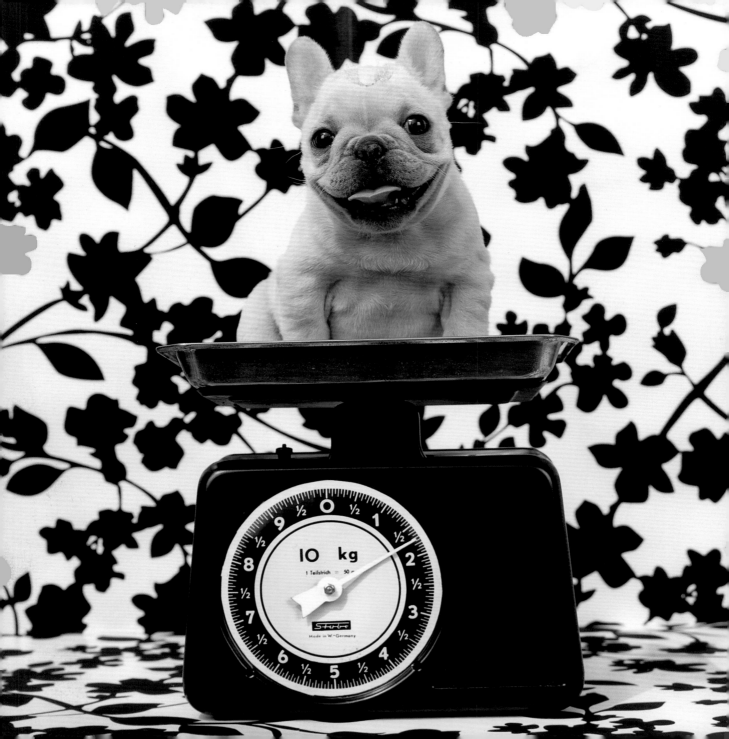

donny **3** lbs. **7** ozs.

marie 5 lbs. 8 ozs.

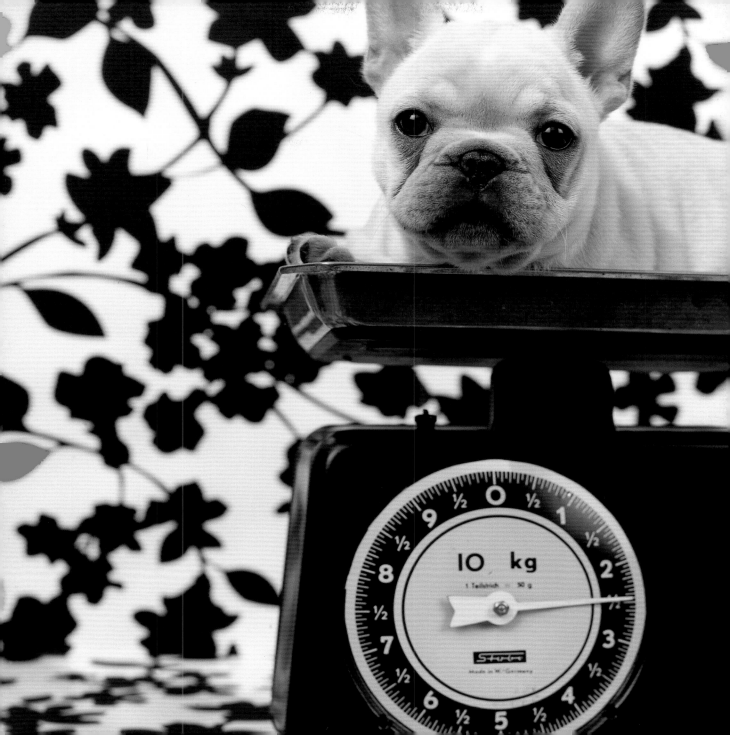

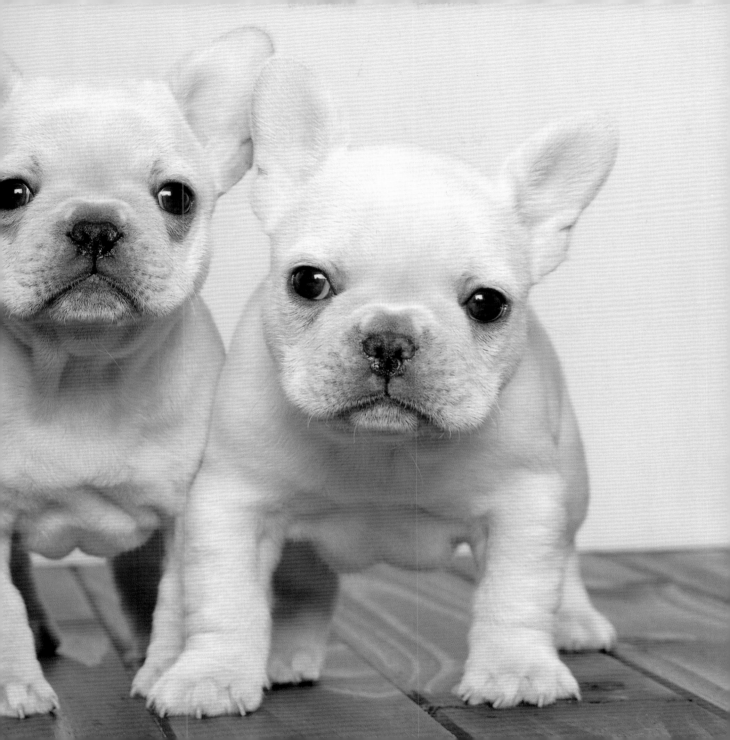

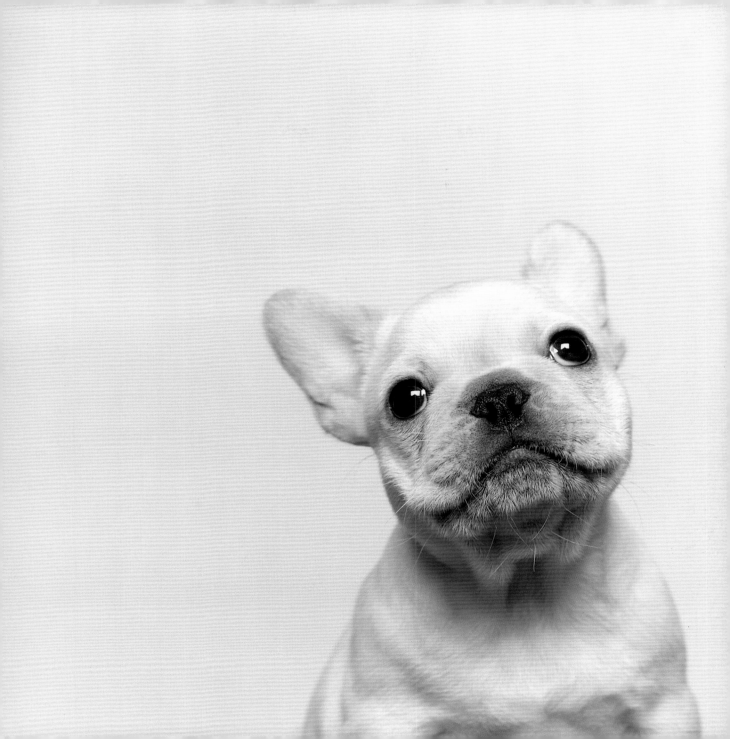

Coco

3 lbs. 6 ozs.

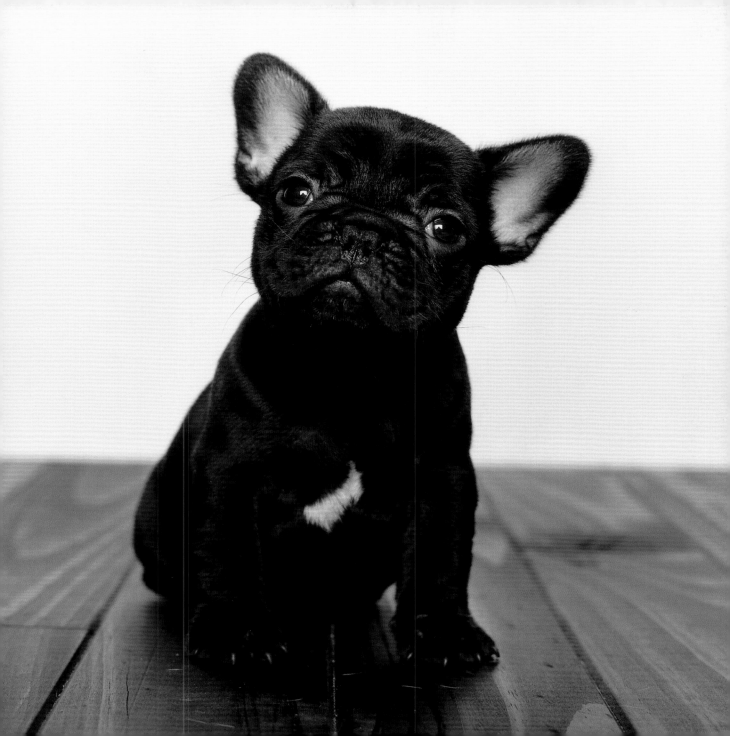

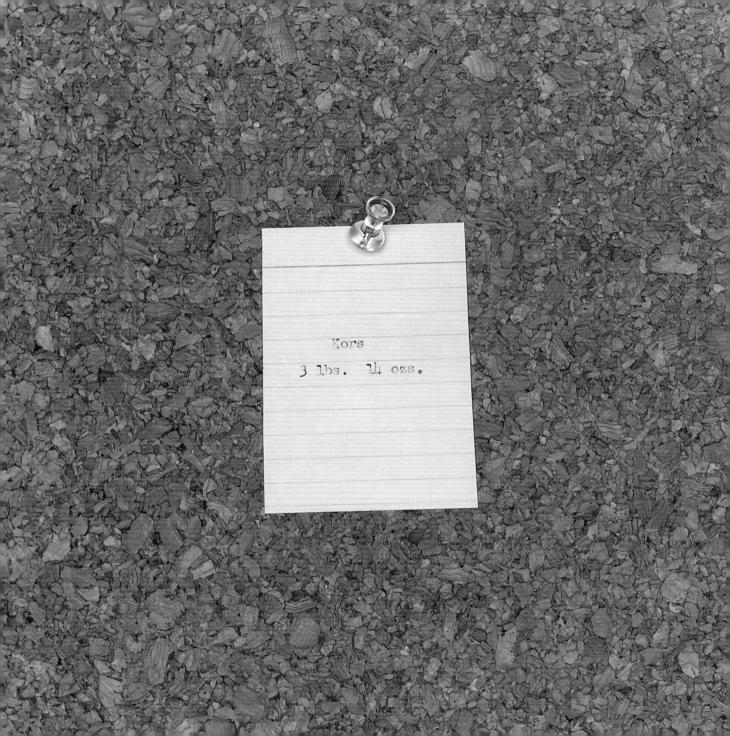

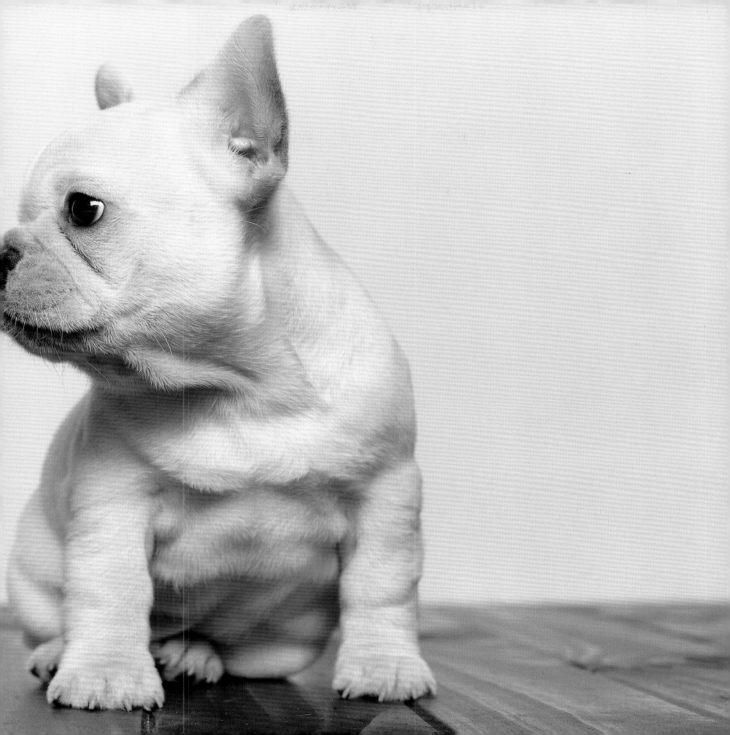

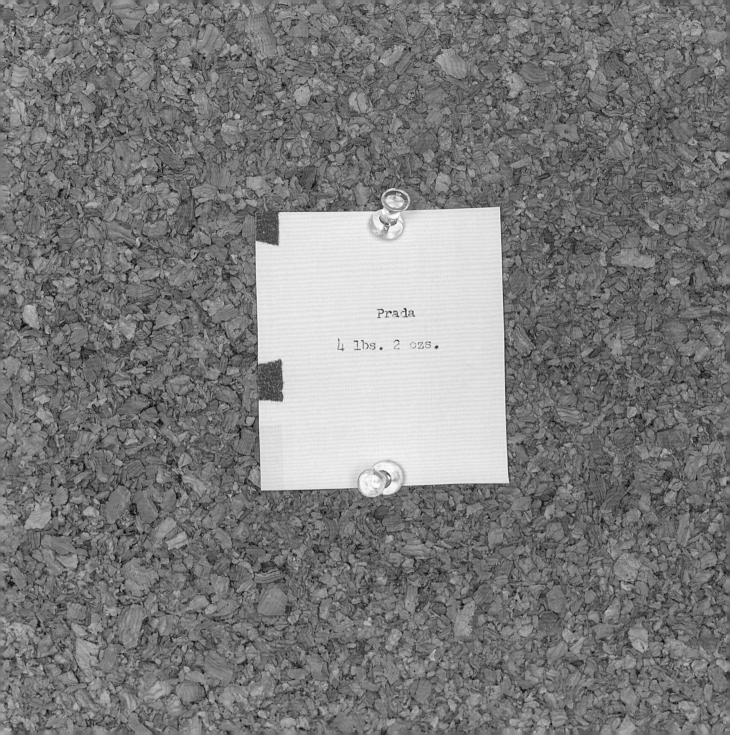

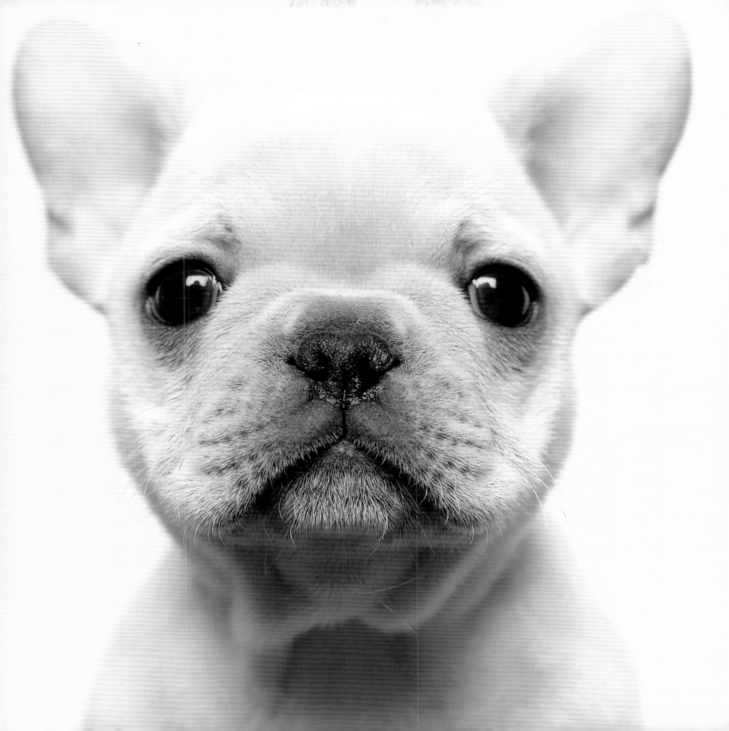

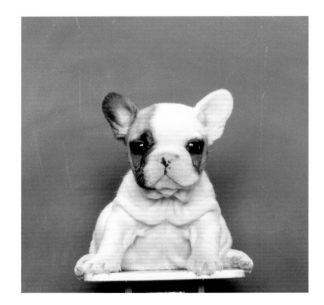

With many thanks to family and friends, as always.

Also, Hendrick and Sally.

Bob Weinberg.

My literary agent, Betsy Amster.

Leslie Stoker, Kristen Latta, and the whole staff at Stewart, Tabori and Chang.

Joe, Carlos Rios, Bonny, Ramesh, and everyone at the Icon.

All the adorable little puppies and their breeders.

And, especially, Spencer Starr.

**Puppies provided by:**

LISA KENDRICK http://bullyrat.tripod.com

LISA KENDRICK http://bullyrat.tripod.com

LINDA MAUGERI www.geocities.com/lindamaugeri

AIMEE MARSH

CHERYL OSMENA www.mysticfrenchies.zoomshare.com

LINDA MAUGERI www.geocities.com/lindamaugeri

LISA KENDRICK http://bullyrat.tripod.com